The Trumpeter Swan

Sue Coleman

Canadian Cataloguing and Publication Data

Coleman, Sue
The Trumpeter Swan

First Edition November 2015

ISBN 978-0-9948321-0-8

Art and design by: Sue Coleman
Editors: Terry Groves, Jessica Coleman.

Printed in Canada by: Friesens

Distributed by:
www.pacificmusicandart.com
Email: Sue@suecoleman.ca

About the Author

Sue Coleman is a re-known West Coast artist who has earned international recognition for her distinctive watercolours that are collected by discerning buyers worldwide. She has written and illustrated several books including the novel *'Return of the Raven'*.

Sue works from her waterfront studio in Cowichan Bay, Vancouver Island in British Columbia, Canada. She paints a wide variety of subjects, but continues to be inspired by the ever-changing natural beauty of the area and the traditions of the Pacific North West People. Her concern for wildlife and the environment is evident in her work, and earns her constant support.

Dedicated to all my neighbours on Khenipsen and Gore-Langton road.
who have watched over our resident trumpeter.

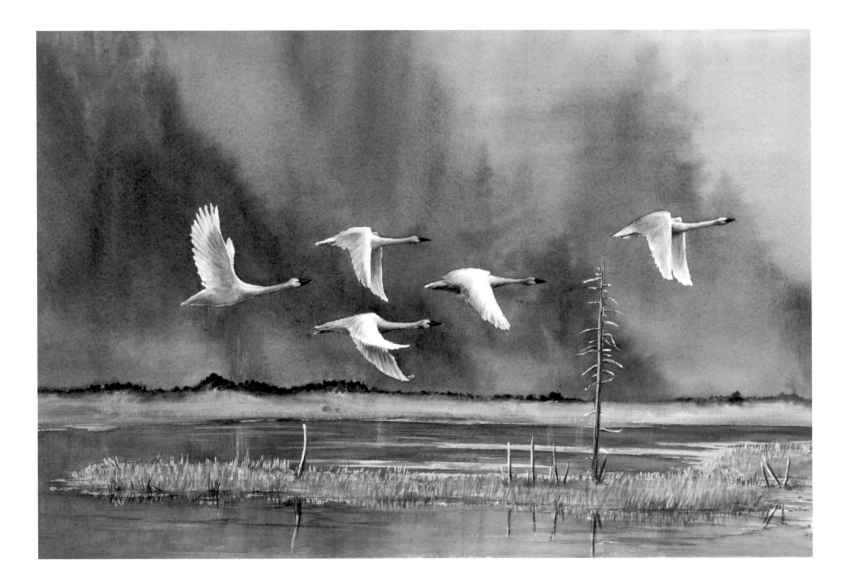

4

The mid-November clouds hung low over the bay as the wind, coming in off the water, pulled mercilessly at the tree tops. It tore at the few remaining leaves that clung desperately to their branches, sending those too weak to withstand the buffeting, spiralling skyward. It was late evening and as the darkening sky absorbed the last remnants of daylight, a small flock of swans flew through the gloom toward the shelter of the marshes where the river flowed into the sea. This valley was their winter home and they returned every year after a summer spent amongst the wild river deltas of Alaska.

Sensing the end of their long journey, several swans honked in weary relief as they started their descent. The flock moving as one, circled, braving the buffeting winds, searching for the best landing. Due to a series of electrical storms, the long flight this year had been one of the worst in their experience. If not for the yearlings need to learn the age-old flight path, the elders would have deviated and found shelter till the bad weather passed. As it was, they over stayed their welcome at some of the resting spots along the way.

It had been an unusual summer. The spring migration north revealed their traditional nesting grounds flooded from an exceptionally high spring runoff and early rains. It was several weeks before they settled in new grounds; ones that were not already populated by another family. Since much of the lowlands were flooded, and they weren't the only family looking, they were lucky to find a secluded spot behind a small island that had somehow escaped all the flood damage. Nest-making and egg-laying had been delayed by nearly a month. The summer had been unseasonably hot, and although they had delayed the fall journey by several weeks, the long flight south had been hard on the young signets.

Familiar grounds within sight, the weary ache in their wings lifted. With renewed energy they headed toward the protected waters nestled between the high banks of the river estuary. The leading elder turned into the wind beginning the final glide toward the inky-black waters below. As if on cue, the wind rose considerably. The regular spacing in the flock's flight pattern was disrupted as the tired yearlings struggled to stay in formation.

Toward the rear of the group two mated swans, their signets flying several wing-beats ahead, honked encouragement as a particularly violent gust buffeted their feathers. Exhausted and concerned for their young, they forgot the cardinal rule of 'space between wings' and in the last moment before their feet touched the water; in the final wing-beat needed to adjust their speed of decent: in those last few seconds of a long, long weary flight, their wing-tips met.

When accidents happen sometimes the results take time to materialize, but not in this case. The fine bones in the wing-tips, already under stress from the battle against the elements, snapped. Their trumpeting of encouragement gave way to shrill cries rarely heard from one swan, let alone two. As they finally came to rest, floating on the dark waters of the creek, they turned to each other, damaged wings hanging as they dipped their injured feathers in the cool water. The signets huddled close to their parents, attempting to provide comfort.

Anguish was reflected by the concerned elders as they paddled back to the small group. Though rare, this was not the first time this had happened. If bones were broken, flight would be impossible. These two young birds could be grounded for the rest of their lives.

The leading elder shooed the signets aside and faced the young parents. They raised their wings in unison although they both knew the outcome was not going to be good. The female looked into the face of her grandfather and moaned, partly from pain and partly from the sadness she saw in his eyes.

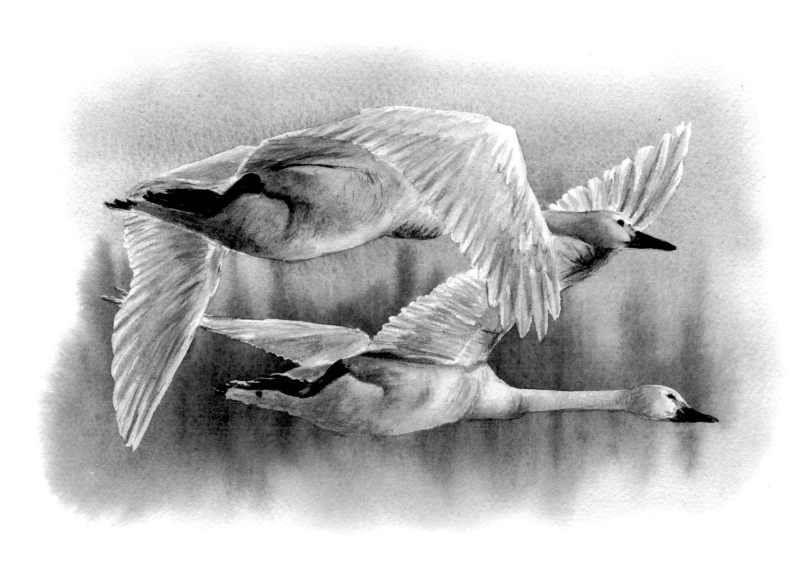

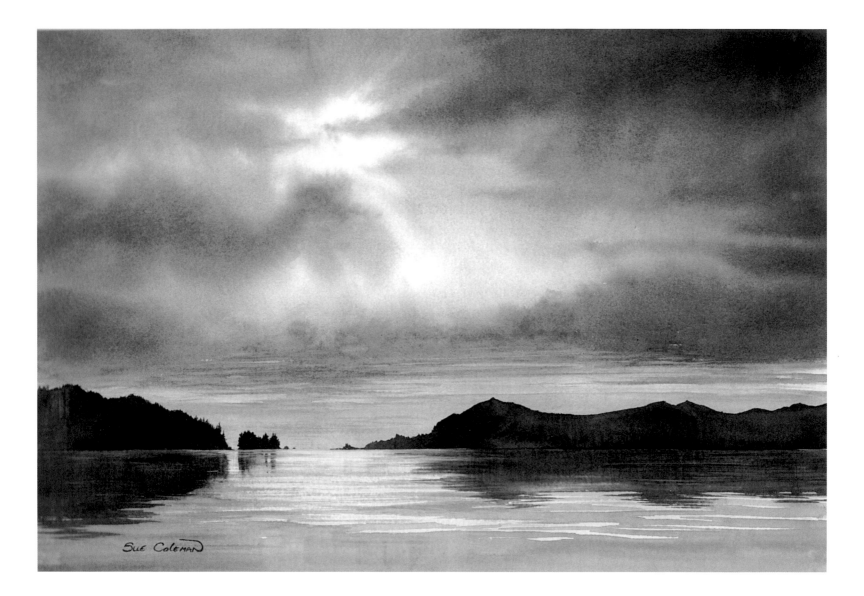

Her mate rubbed his head across her neck. He felt responsible. He should have realized her concern for their youngsters would outweigh her usual caution. He knew both he and his mate were in pain, but the severity of the accident hadn't sunk in yet. Little did they know that neither of them would travel to their beloved summer nesting grounds again.

In typical Pacific Northwest fashion, the wind exhausted itself during the night. By next morning the surface of the water was disturbed only by a ripple that gently slapped at the pile of logs behind which the group of swans had found shelter. The gulls, having fled inland at the onset of the storm, had returned. Their cries could be heard as they circled the bay, searching the tide-line for the possibility of an easy meal. Remnants of rotting salmon from the recent salmon run could still be found if one looked carefully.

The waters were cloudy with river silt; but that didn't hide the few small drops of blood coming from the wings of the sorry couple. The night had been difficult. Unable to see how bad the damage was, all they could do was suffer in silence while their tired and exhausted family slept. The female, we will call her Serene, suffered worse than her mate, Koban. The wing she had damaged was the one she usually tucked her head under in sleep. Still both birds found it un-natural and uncomfortable trying to rest yet keep one wing-tip in the cold water.

In the early morning light, one of the female elders, known for her knowledge in plants that heal, paid them a visit. She looked close at the wounds, gently lifted the broken feathers and probed the torn flesh. She had brought some marsh weeds which she laid across the raw skin all the time muttering to herself. She gently rearrange the bent feathers, ignoring the gasps of pain. Careful to avoid Serene's eyes, the elder told them they must each rest their wing-tip across their back as best they could and to avoid using their wings for at least a week. She had done her best to straighten the bones, but deep within her soul she knew there was little hope that they would mend.

By mid-morning a sorry looking little family of swans paddled through the marshes to the edge of the ocean. The tide was out and the mud flats stretched across the wide bay. The river had cut a channel through the mud and built bars of silt, sand, and gravel. The rest of the flock had gathered on one of the gravel bars and been joined by other groups still arriving from the north. Each honked a loud greeting of encouragement as every swan in the vicinity had heard about the unfortunate accident. Each was acutely aware it could just as easily have happened to them.

A tough week followed. Learning to do everyday things without moving your wings was hard. Not being able to stretch and have a good flap in the morning, keeping your wings tightly folded when feeding, it seemed every activity had to be curtailed or adjusted.
The burning pain eased and numbness set in. Resignation followed when the week passed and the wings had not even begun to mend. The fragile bones were shattered and, without further intervention, would not straighten. The skill to mend broken bones was not within the abilities of even the most knowledgable swan.

There was a small scattering of human residences along the shore of the bay. Many of the owners would come to the water's edge and throw grain for the swans, glad to see their return. More than one of the humans showed concern when they spotted the two swans with broken wings but, try as they might, the swans wouldn't let them get close enough to help.

Neither Selene nor her mate were used to humans. Apart from receiving a free meal, which in itself was suspicious, they were cautious and careful not to let them get too close. Humans were known throughout the world of waterfowl as the bearers of sticks that kill. The fact that it was mainly ducks that fell out of the sky when the stick was pointed at them was noted,

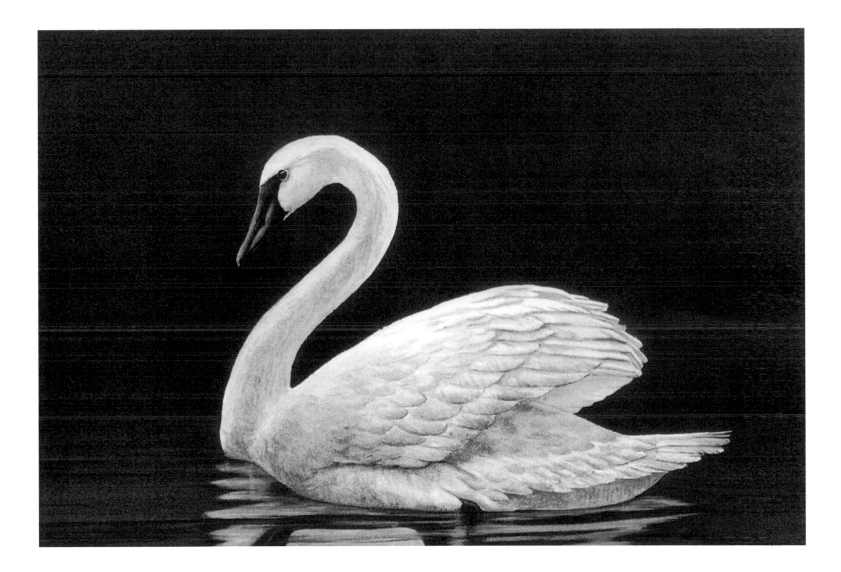

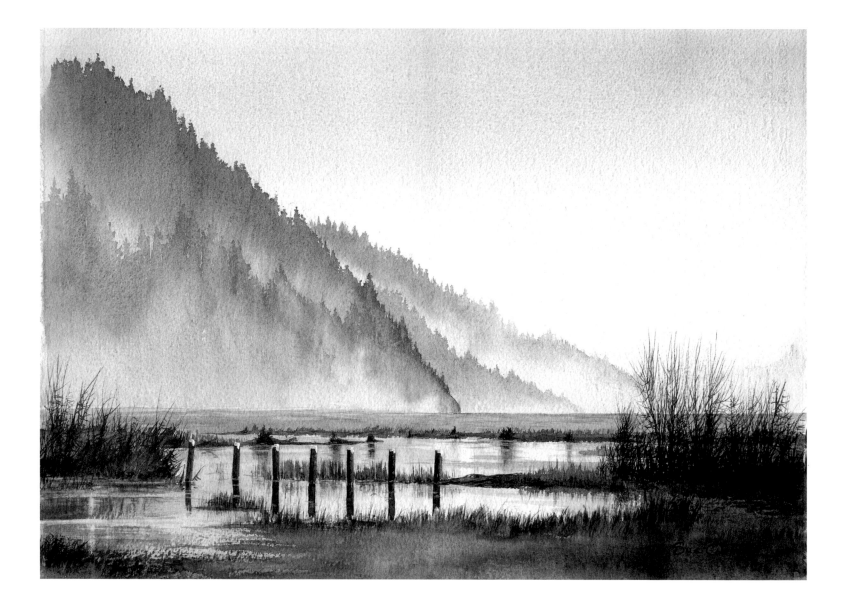

but the shock of seeing a free flying bird die in mid-flight was enough. Ducks today, swans tomorrow, was the motto of many of the elders. So, when the humans tried to approach the injured birds, they swam quickly out of reach. A damaged wing doesn't prevent a swan from moving swiftly on the water.

As winter dug in its claws, the group settled into their usual routine. Feeding in the shallows in the morning and resting in the shelter of the marshes, or out on the flats in the afternoon. After the November storms had passed December and January followed: mild with clear skies and only a few snow flurries.

The family stayed close together even though the rest of the flock made several trips inland to the cornfields. These were the meeting grounds for the families where a meal could always be found between the stubble. Catching up with the latest news from old friends was a pleasant way to waste an afternoon. It was also a chance for the signets to mingle and find a mate. Serene and Koban missed those trips to the fields. Although their signets were none the wiser, Serene worried that they were missing a chance to socialize. Ever hopeful that their wings would heal they spent their days exploring the different channels in the marshes and going further up the river than they had ever paddled before. Things were different at ground level, perspectives change, and one afternoon they discovered one of the small creeks ran right beside the main corn field. Selene became excited. She had never noticed the creek before when visiting the fields. When you could fly, there was no need to map out the channels in the marshes.

It was a struggle to get up the steep bank, especially with damaged wings, but worth it as the few swans that were in the field quickly flew over to greet them.

Thrilled that their signets finally had an opportunity to meet the other young swans, the adults watched as the immature males eyed up the exited newcomers. Serene felt a surge of relief now that her signets had found new friends. After all, the winter was the time to court and find a mate.

As winter waned and the days grew longer, the youngsters stayed with their new mates more and more. Soon the two injured birds found themselves alone. Serene and Koban swam together everywhere, hardly letting each other out of sight. They groomed each other's damaged wing-tip and helped the other whenever it was needed. They grew closer as their nest emptied.

One day in early March they received a visit from Serene's father. He reminded them it would soon be time to gather the flock and prepare for the flight north. All of Serene's signets had found partners so each would travel with their new mate's family. He assured his daughter he would keep an eye on his grandchildren so she need not worry, they would be taken care of. Her fathers words brought on the realization that they would never travel north again. Her and her beloved Koban were bound to this estuary for the rest of their lives. While the rest of the flock prepared for migration, Serene and Koban stretched their wings daily and tried to fly.

The trumpeters began to leave. First one family decided it was time, then another followed. Soon the air was full of trumpeting swans. Finally it was time for Serene's signets to leave and they honked a mournful farewell then joined their new partners in the air. The formation turned north, flew low over the bay, gained height, then finally flew over the tops of the trees and out of sight. In one last frantic effort Serene flapped her wings running across the mud flats, struggling to gain some altitude. All she managed to achieve was a painful, throbbing wing and the tip began to bleed again.

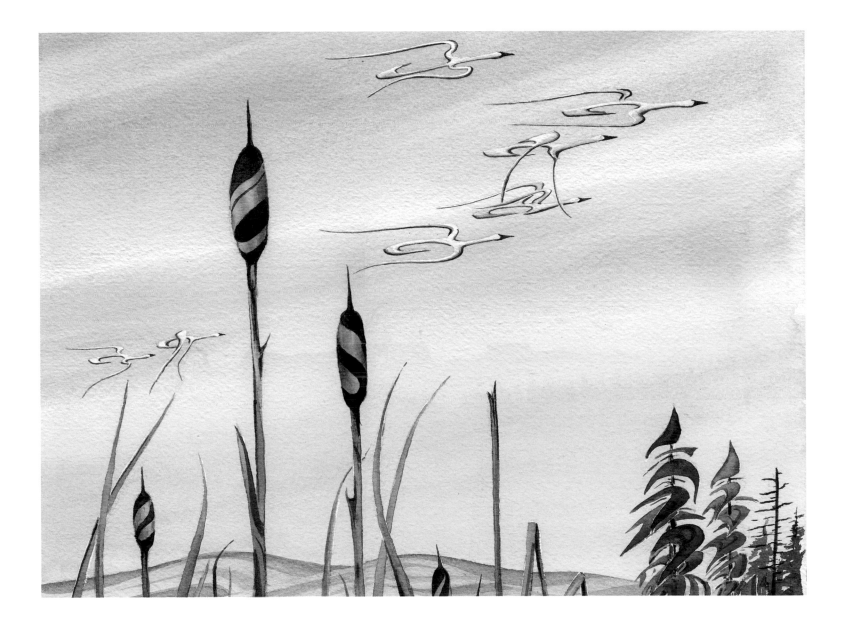

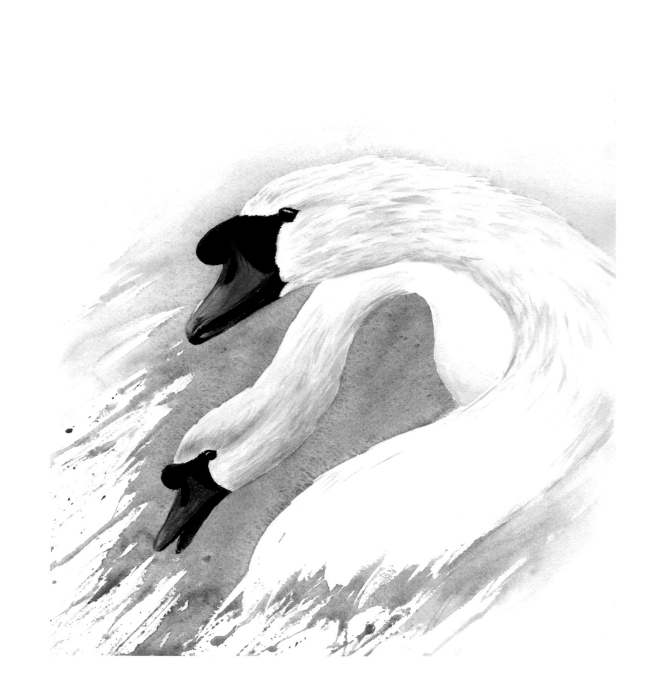

Koban tried to calm her although he too felt the overwhelming urge to leave. He knew they couldn't go. Now they needed to focus on another problem that would soon raise its ugly head.

The marshes that are one of the winter feeding grounds for the trumpeter swan are located toward the southern end of Vancouver Island in British Columbia. This sheltered glacial valley, nestled between two mountain ridges, houses a large lake along with several rivers that drain into the ocean. Two of the main rivers come together in this wide bay, creating a maze of creeks and channels before cutting through the mud flats and meeting up with the sea. This diverse wet-land, protected from development by a group of humans that like to shoot ducks, was also the nesting grounds for a large number of mute swans which, unfortunately, do not tolerate trumpeters.

The mute swan is an introduced species that originated in Europe. Not indigenous to Canada, they do not migrate. The marshes had been the winter grounds for the trumpeter long before the human settlers brought their smaller European cousins to this land and they returned every fall in large numbers. When the fields, flats and waterways become host to around a thousand trumpeters the fifty or so mutes lie low, staying well away from the local indigenous species. Why the trumpeters left every spring was not in the realm of mute understanding but when they did, there was a welcome relief from all that honking. Within a week, the mute swans had reclaimed the marshes and mud flats, courting was in full swing and the serious job of finding a good nesting site was of uppermost importance.

Suddenly Serene and Koban found themselves in a minority situation. Used to having a large flock around them they felt isolated and more than a little unsure of themselves.

Trapped within the estuary, now it was they who hung back when the mutes were on the flats, and they who vacated the marshes when the mutes were building nests.

As the days became warmer Serene felt less and less inclined to nest. Nothing felt right. The water was too warm; the sun was too hot; it was the wrong type of grass and reeds for the nest but, most of all, her wing caused her many sleepless nights. The last thing on her mind was eggs. Koban had other thoughts but was tolerant of her moods. Besides, how were they to teach their young the most fundamental lessons in flying if they themselves couldn't fly?

Several of the mutes noted their presence, ignoring them at first, until one morning a male mute decided to challenge them. It was well into the nesting season and Serene rested on the shoreline in front of the residential houses, well away from the nesting grounds. Koban lazily pecked at weeds in the shallows when the mute suddenly flew across the open water. He landed just in front of them, spreading his wings wide and hissing in anger. Both injured swans honked in surprise and backed into the tall grasses. The mute swam back and forth in front of them and curved his wings high above his back in challenge. Koban stretched himself as best he could and, being a larger bird, looked quite intimidating. A damaged wing did nothing to lessen his bite. As he recovered from the shock of the aggressive behaviour, Koban took a few steps back toward the water's edge, honking a loud angry challenge in return. The mute didn't expect the injured birds to be so defensive and back-peddled into deeper water. He continued to hiss a warning, but to Serene, who quickly joined her mate, it sounded a little less sure. The trumpeters stood their ground. The challenge lasted over an hour as the mute paced the shoreline sometimes swimming closer but always just out of reach of the trumpeters who had now taken to the water. It was a standoff. Finally the mute swan turned and swam casually away. He could have flown but he wanted the trumpeters to know that he was not leaving in fear of them. He swam slow and graceful back to his flock; he had made his point.

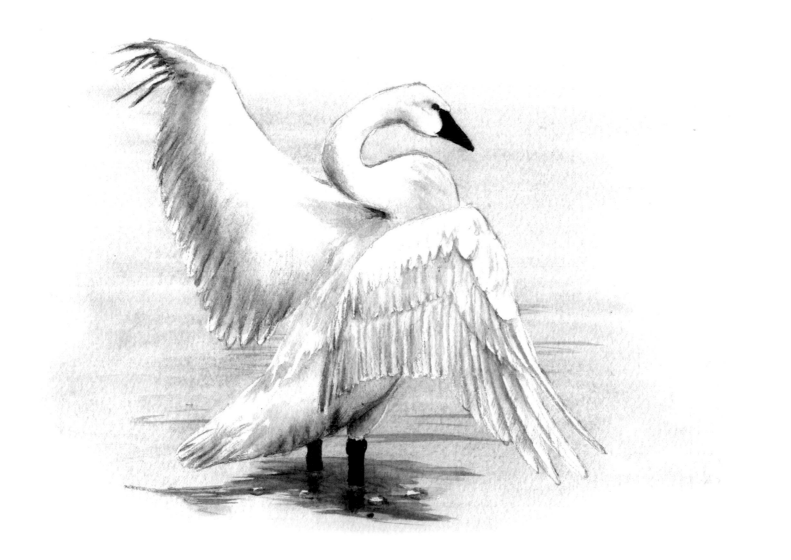

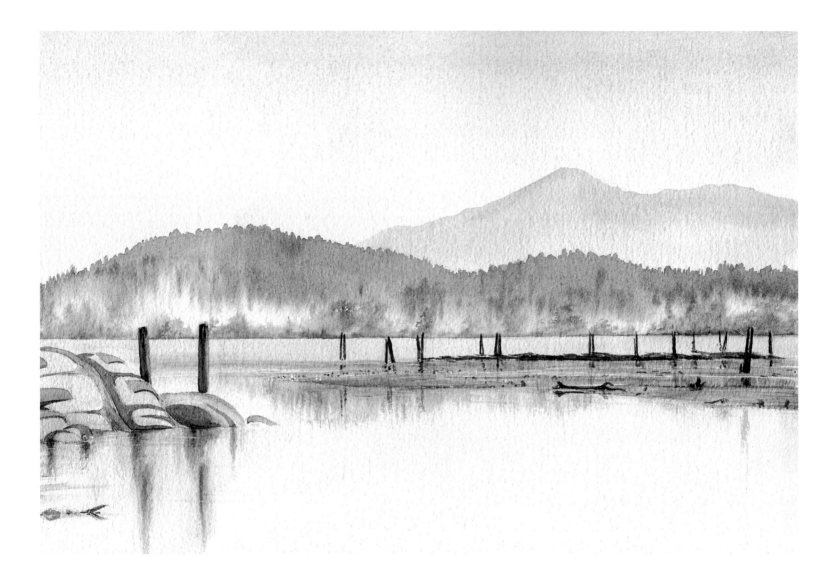

He had also established that the intruders were not a major threat as the trumpeters had not attacked him. If the foreigners kept their distance then all would be well: a stalemate. It was a big bay and, as long as these noisy birds stayed well away from the mute nesting grounds, they could be tolerated.

If Serene had any remaining thoughts about egg laying, the confrontation wiped them from her mind. As spring stretched into summer, Serene and Koban stayed out of the marshes and found themselves a shallow shady corner of the bay. They were closer to the houses, a part of the shoreline less popular with the mutes except when they were looking for a hand out. Tall grasses gave way to a gravel beach with a few rocky outcrops. Here, the ocean was quite a bit cooler than the river, the temperature of which steadily rose as the summer wore on and the days became long and hot. The breeze that came off the sea helped to cool the birds who were used to the cooler northern climate.

At first Serene missed the smells of the northern muskeg, but as the lazy, warm summer days wore on, her memories faded. The heat made her feel lethargic. Neither trumpeter was aware just how lucky they were to have been stranded in their winter home. Had the accident happened in the north, they would never have survived a harsh winter where the ground freezes hard and is covered in at least ten feet of snow. If the cold didn't kill them, the lack of food would. Here in the Warmlands, food was plentiful year round and they didn't have to travel far to find it. In this valley of plenty, being able to fly was a luxury, not a necessity and, under the circumstances, apart from the occasional feeling of loneliness, life treated them well.

Summer turned to fall and the days grew shorter. As the weather cooled, the pair felt renewed strength. The urge to fly south was still programmed into their memories but, confused by the fact they were already south, little, everyday things made them irritable and edgy.

21

Then came a wonderful morning when Serene, who had been abstractly nibbling at some fresh weeds, heard a distant sound. Memories stirred and happiness welled up from deep within her soul. It was the honking of a trumpeter and it was getting closer. Suddenly the whole flock was overhead and as they flew over, the two grounded swans flapped their wings and rose up on their feet, stretching their necks, honking in reply.

A small group broke formation, circled, and eventually settled on the water. They paddled closer. Serene's heart swelled as she recognized her family and saw their new offspring. Much honking and wing flapping ensued with introductions and exchange of news. It seemed the flock had grown anxious over the outcome of the stranded pair and so their group had been one of the first to leave the nesting grounds. Before the week was out, group after group of trumpeter swans flew into the bay. As each flew over the family, they honked a cheerful greeting, glad to see that the injured birds had survived the summer.

With the strength of numbers, the trumpeters reclaimed the marshes and the mutes vanished. Whether they went up river or to the lake, no-one knew or cared; the family was together again. Winter passed without incident. Serene and Koban, well used to their inability to fly, had learned to move quickly through the water. They had gained added strength in their leg muscles and when the younger birds travelled with them through the marshes they had to make short burst of flight to keep up. Winter and family was a happy combination for the injured birds.

All too soon March rolled around again and, before the swans knew it, the time came for the family to leave. Serene's grand-signets had found partners and their urge to fly north, back to the nesting grounds, grew stronger as the month rolled on.

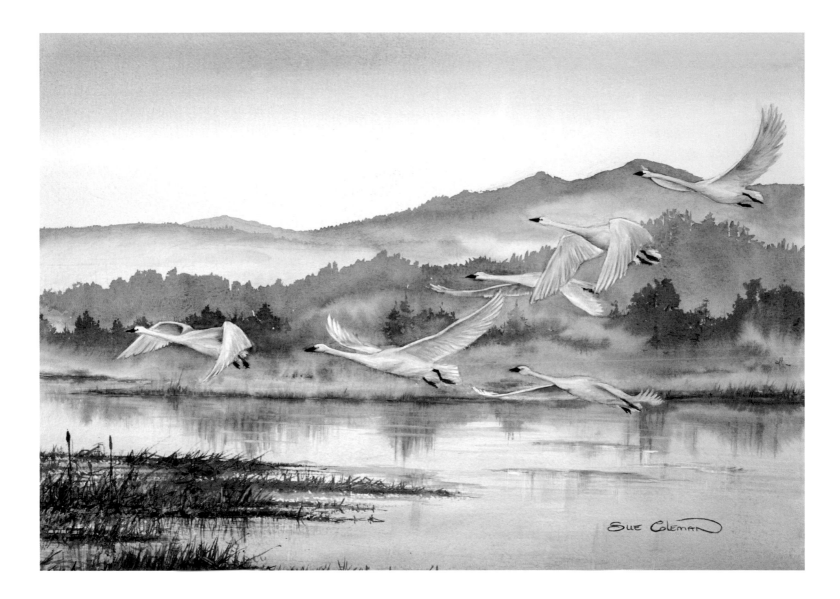

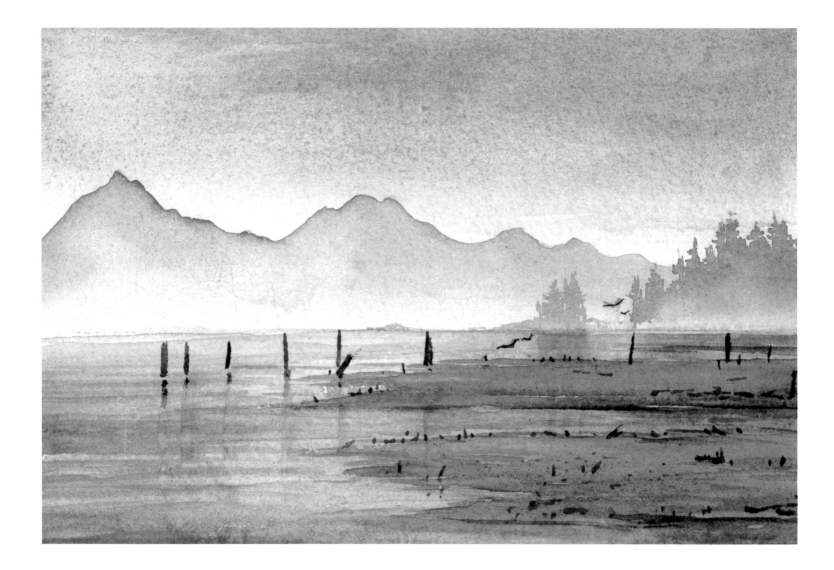

Then the day of parting arrived and, when their family took flight, the injured pair again tried to fly. Their broken wing-tips, long since healed over, caused a dull ache as the unused muscles tried to force the broken bones to move. Unwilling to give up, Serene tried again and again. She ran with her now powerful legs across the mud flats, but could barely get off the ground. With only one healthy wing able to gain any lift, she found herself going in circles. It was two days before she resigned to her fate.

Three days later the mutes re-appeared and the trumpeters retreated to their secluded beach. With the houses so near there was no thought of nest building and the pair tried to settle back into some sort of routine.

The mutes left them alone, although the male mute swam past several times as though to assure himself again they were no threat to his flock. He swam by with his wings raised in a show of strength but other than that, didn't bother to challenge them again.

In early summer, when the spring rains eased and the suns warmth began to become uncomfortable, things took a turn for the worst. It was an overcast morning and both trumpeters were enjoying a refreshing rain shower that did wonders for washing the salt out of their feathers, when disaster struck. Both birds were in deep water, unable to touch the bottom, and the ocean itself was murky from the silt that had washed down the river in the recent spring storms. A large male otter took advantage of the situation.

Swimming silent in the shadow of the rocks until he was opposite the pair, he then dove deep and swam quickly through the cloudy water, until he was under the unsuspecting swans. Although his usual fare was ducks, he had become well practised at this form of attack and his powerful jaws snapped around Koban's leg.

The greedy otter had no idea what he was up against. It was easy to drag a duck under the water giving it little chance of survival. By the time the otter would return to shore with his victims, most of them had drowned. Not so the swan. Even though surprised Koban, struck hard with his beak and the otter had to come up for air. Giving his attacker a nasty gash across his head and stunning him for a few moments, Koban turned and paddled swiftly toward the shallows.

Now would have been an excellent time to take to the air and get out of the water ... if they could fly. Honking in fear, both swans headed for the beach as the enraged otter regained his senses, dove, and struck again. This time he broke bones in one of the male trumpeters feet then turned quickly away before the swan could strike again. Otters are incredibly agile underwater and although he lacked the strength to pull the swan under, he continued to attack the underside of the bird. First one leg, then the other, merciless. By the time the struggling swan reached shallow water he couldn't stand. Now the otter attacked in earnest. He nipped the swan from all sides, like an attack dog.

The loud honks from the distressed birds alerted the human inhabitants and before long several came running to the shore. One braved the cold water and waded toward the struggling swan. The otter, seeing the human fast approaching, reluctantly abandoned his prey and fled back to the rocks.

Serene watched from the beach as the human lifted Koban from the bloody water. His head hung limp and Serene could see he had no fight left in him as he was carried to shore. Several other humans ran to help but as they gently set him down on the gravel, everyone, including Serene, could see the ghastly wounds the otter had inflicted. Suddenly, with a shudder that was probably partly due to shock, Koban died.

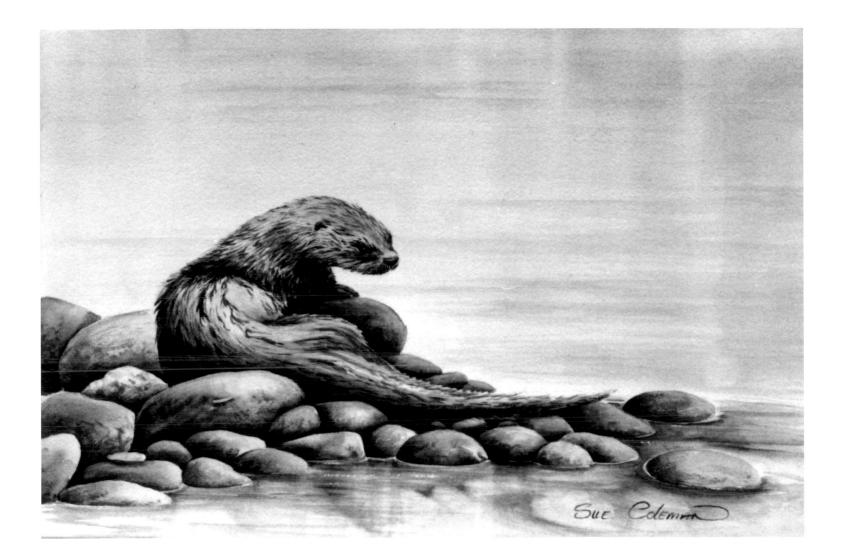

Sue Coleman

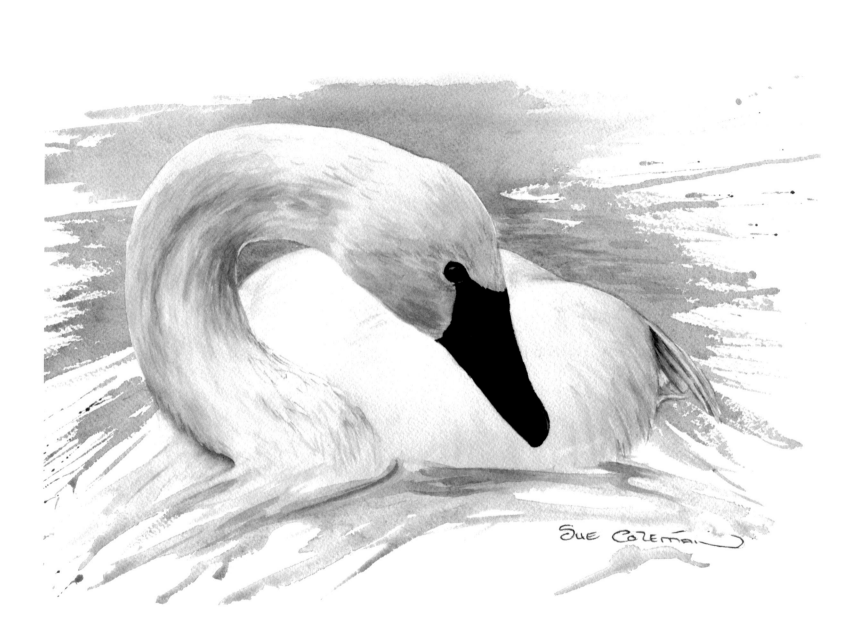

28

All eyes turned to Serene who continued to honk in distress. She wanted to go to Koban, to comfort him, to wake him. When one of the humans started to walk in her direction, Serene turned and fled along the beach and out onto the mud flats, getting as far away from all humans and otters as she could.
With the rest of the summer ahead of her, Serene found herself utterly and completely alone.

Well away from the shore, out in the very middle of the mud flats where the river and sea met, our terrified female trumpeter swan stopped running. Here she could see all around her for a great distance. Here nothing could sneak up on her without warning.

It finally stopped raining and a rather watery sun peeked out from between the clouds. Serene settled down on a patch of gravel and sand: tired, distraught, and shaken. She didn't stay there for long. Before she had time to calm herself or gather her thoughts, water lapped at her feathers. The tide was coming in and before the end of the morning, the mud flats would be covered.

Nothing in the world of swan would make Serene go back to the sheltered beach alone. She honked for Koban again and again. Koban was gone. In desperation she looked toward the marshes and wondered. The nesting season was over. As she scanned the reeds and grass banks she spotted a small family of mutes at the river's edge. 'Safety in numbers' was her one thought as she quietly paddled up the river toward the group.

The pair of adult swans were so engrossed with watching over their young as they swam in the shallows, that Serene was quite close before the female mute saw her. The male had been scanning the skies and the tops of the trees for eagles and any other air-born danger when he heard the hiss of warning from his mate. He turned, looking for the threat, just as Serene lowered her head in submission.

They were a young family, this being their first hatching. Both parents had been aware of the pair of trumpeters for well over a year, but these local native birds had not been a threat before now. Something had changed. Where was her mate? Reluctant to fight a large male trumpeter, the male mute looked around the bay prepared to protect his family, but there was no sign of the other trumpeter anywhere. Confused he raised his wings hoping to intimidate, but Serene was already in submission. He took a few threatening steps towards her and Serene stepped back but didn't leave. He hissed at her and she answered with a quiet little honk. It was more a plea. What did she want? She seemed to be shivering but it was not a cold day. There was even a glimpse of the sun. When Serene raised her head he saw anguish and fear in her eyes. Where WAS her mate?

It was the look in those eyes that decided him. If he ignored her, maybe she would go away. He turned back to his family, assured his wife that there was no danger and returned to his job of watching the skies. His mate, not so sure, kept a watchful eye on the intruder who seemed determined to stay. When one of her signets showed curiosity and swam toward the trumpeter, she watched closely for any threatening move.

Serene eyed the signet. Another stab of pain hit her heart and she let out another subdued sad honk. Startled by the unusual sound coming from an adult, the signet turned and swam back to its mother. Maybe her mate was right and this foreigner was not a threat ... yet. Slightly reassured but not totally convinced, the female mute returned the honk with a warning hiss. Then she too decided to ignore Serene. As the tide slowly crept in across the mud flats, the mute couple gathered their offspring, took to the water, and turned upstream toward the marshes. About ten paddles behind, Serene followed.

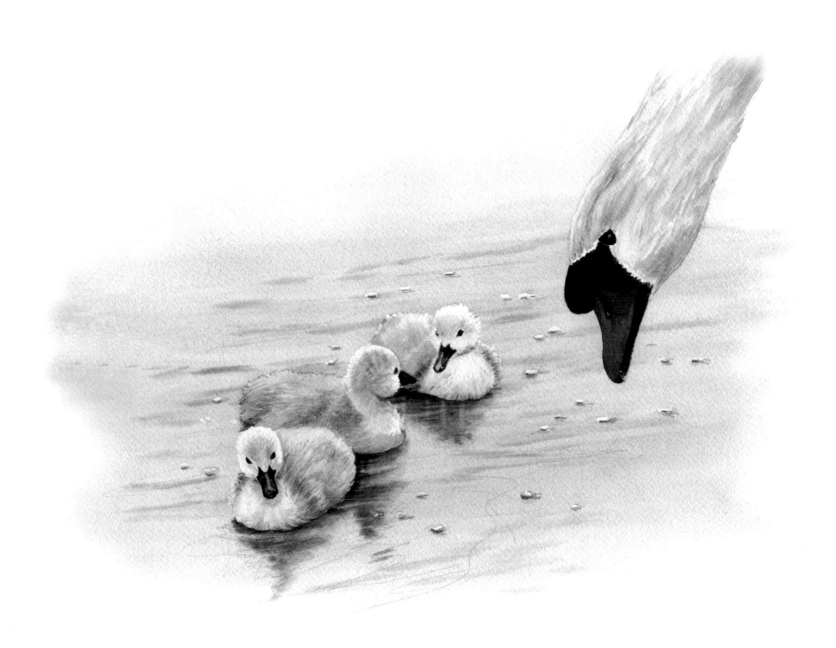

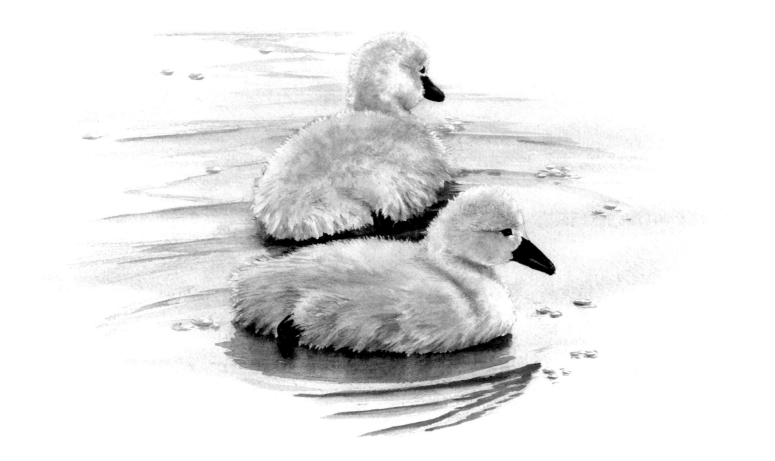

Over the following weeks Serene stayed close to the mute family. Not so close as to upset the parents, but close enough to feel safe from predators. The signets became so used to her that they treated her as a strange aunt. The mutes now had three sets of eyes to watch over their offspring and it didn't take the youngsters long to learn the difference between a gentle honk of approval and one of warning. During the early part of the breeding season the different mute couples kept to themselves, but by late summer they began to gather in groups allowing the young swans to meet and get to know each other.

By now the adult mutes had come to accept Serene's presence. A few eyebrows were raised by other mute families but, as she wasn't their problem, they basically ignored her. Although she still kept much to herself, at least she didn't feel completely alone and the signets were quite friendly toward her. She was different and therefore exotic. Her honking made them laugh. Now she could travel the marshes without fear of confrontation and quite often the signets joined her when she went for a morning paddle. She had become a favourite aunt.

Communication skills were lacking but the male mutes had long since included her in their realm of protection. Exactly how much they considered her part of the family was soon to be tested. As the evenings began to draw in and the leaves on the trees turned golden, the male mutes began watching the skies. Not for eagles or an impending storm, but for signs that it was time to move to the lake.

It was one of those unusually warm sunny days in late November when Serene heard the distant call. Honking loudly in excitement she swam quickly out of the marshes into the open ocean as the first group of trumpeter swans cleared the tops of the trees. Fearing for her safety, the adult male from her adopted family flew across the water to land in front of her as the first set of trumpeters landed on the water. He raised his wings, showing the newcomers

that Serene was under his protection, an unusual and brave action for a mute swan. Never before had a mute challenged a group of incoming trumpeters, but he now considered Serene a family member.

Serene was confused. Her adopted family were protecting her from her own signets. She honked a warning to her oldest son who was swimming toward them with raised wings ready to answer the challenge. Then she calmly swam up to her misguided protector and gave a quiet gentle honk as she paddled past him and joined her own family. Another clipped honk at her son and he slowly lowered his wings.

The quizzical expressions in her children's eyes told Serene there was a lot of explaining to do and she honked happily as she counted the heads of the new additions to her family.
Yes, her family. Looking back she watched as her adopted protector also lowered his wings. With a shake of his head he turned, more than a little confused, and joined the group of mutes watching from behind a stand of bulrushes. Gathering up the rest of his family the male mute could offer no explanation to the signets who, puzzled at the turn of events, were sorry to see their favourite aunt leave with a bunch of strangers. It was obvious she was not coming with them to the lake, so following the direction of their parents they silently took to the skies, heading inland away from the incoming invasion of strange, noisy birds that incessantly honk.

The winter months passed. Several of the grand-signets chose to take turns paddling with grandma-ma. Wherever she went, she was never alone. The male trumpeters, now alerted to the potentially dangerous attacks that could come from otters, were ever vigilant. An otter attack on a swan had not been recorded in their history. The chance of an otter finding a swan that was so injured it couldn't fly was rare, enough so the chances being swayed toward the otter winning were low.

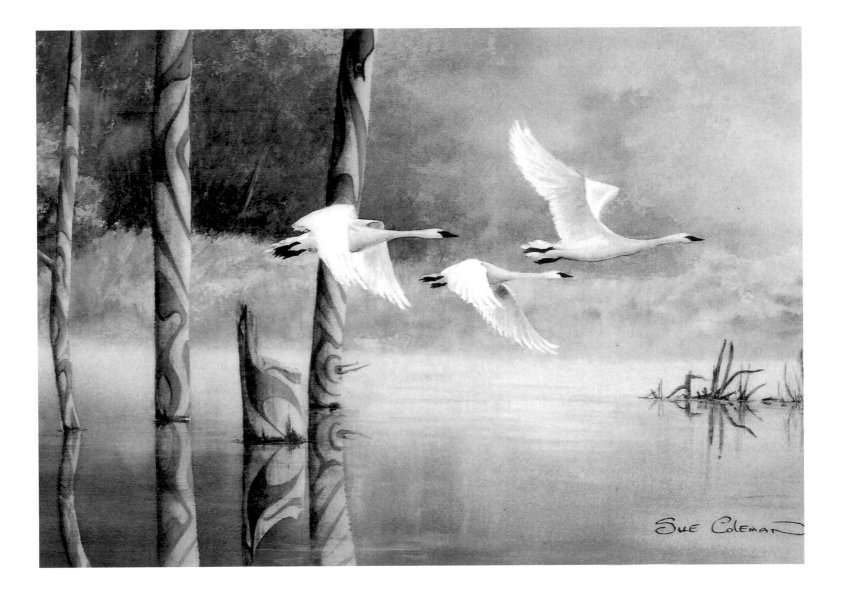

Winter gave way to early spring and a feeling of dread began to creep over Serene. Again she tried to force her wings into flight. As families began to gather, ready for migration, she flapped her wings in frustration. It was time to leave and when her family finally took to the air, they circled watching in silence, as she frantically struggled to join them. Her one remaining wing was now weak from lack of use and a tearful Serene resigned herself and honked a sad farewell.

Alone again, Serene stayed in the protection of the marshes. She slept on the grassy banks at night and stayed in the shallows by day. One morning, just days after her family had left, she heard distant honking. Her spirits rose but as the sounds grew louder she realized it was just a flock of Canada Geese coming up from the south. She shook her head, unable to believe she had actually mistaken their noisy racket for the more sophisticated call of a swan. Her mind was playing tricks on her.

And then the mutes returned. Silent as usual, they flew in and suddenly she was no longer alone. Without fear she swam to greet them honking her pleasure at seeing them again. However, the male in her adopted family was not easily placated. She was after all a female and he had felt betrayed. He stayed distant. The meeting was a cool one. Even the signets, who were now full grown and had been courting most of the winter, showed little interest in her company. Their only thoughts now were on finding a good nesting site. With the mutes focusing all their activities toward mating and egg laying, Serene found herself ignored. She watched wistfully from a distance, old yearnings rising in her chest. Maybe the grasses weren't so different, the warmth in the water was tolerable and some shade from the sun could be found under clumps of bushes growing along the river's edge. With nothing else to do she went searching the channels and one afternoon found what could possibly be a perfect nesting site. Well back in the marshes, several old pilings from the past logging days still stood. Logs and

a couple of large tree roots, pushed up and over the mud-banks at high tide or during winter storms, had piled up against them. They had been there for several years resulting in reeds and grasses taking root, growing up, around, and through the timbers, creating quite a tangle. The mutes showed no interest in the log pile, but when Serene watched a heron work his way under the logs, looking for fish in the shallows, she decided to investigate.

Quite unexpectedly she discovered a hollow in the center of the logs with enough room for three full-grown swans. The ground underneath was comprised mainly of silt trapped during the spring run-off. Although it was a little damp it was not muddy. The cool sand would provide welcome relief during hot summer days. The logs provided shade and shelter and, on careful inspection, she could see that, thanks to the debris that had given root to the grasses, there were very few spaces from which an otter or any other enemy could attack. Serene felt pleasure from knowing she had found herself an unusual, but ideal, nesting site for a bird who couldn't fly.

Her joy was short lived as she remembered she had no mate. Still, as she surveyed the perfect hollow, she decided to make a nest anyway. With all the other birds sitting on nests or tending to them, what else did she have to do to occupy her days?

Serene had only ever built one nest and she figured it was unlikely she would ever build another so she took her time searching the river banks for the driest grasses and the finest reeds. Then she hunted for any type of moss that would remind her of the muskeg in the north. She had seen the redwing blackbird tear at the tops of the bulrushes and decided to try that herself. If it was good enough for a redwing's nest then it should work for hers.

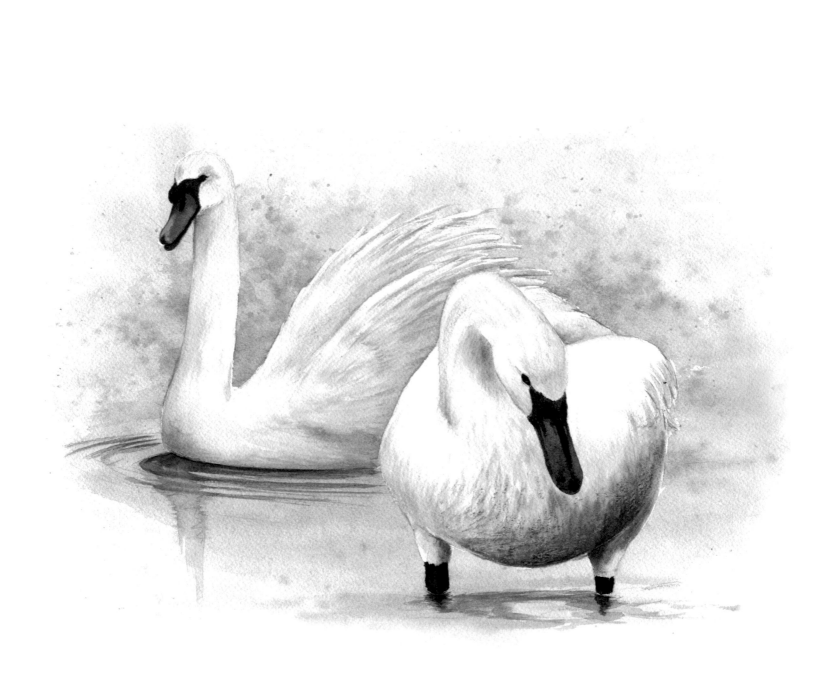

Finally she lined the nest with her own down. She didn't rush. In fact close to a month passed before she realized there was nothing more she could do. The nest was finished and she had to admit it was the finest nest she had ever seen.

Serene's activities didn't go completely unnoticed. One morning, not long after she had completed her nest, a young male mute approached her. He raised his wings, but not as high as a challenge, and swam around her in what she could only interpret as a courtship dance. Her instinctive urge to lay eggs was still there but this was a strange courtship. No sweet honk of love and little chance of any understanding between them. Any long-term relationship would be doomed and, as swans mate for life, Serene wasn't ready for more heartache. She backed up onto the beach honking loudly, doing her best to show her refusal. The young mute didn't give up easily. This was obviously a female playing hard to get. He was young, good looking and strong. She was attractive, exotic and obviously needed a mate. Stubbornly he strutted his stuff and it was well into the afternoon before he finally accepted defeat. Her rebuff damaged his ego. Humiliated, he returned to his small group of single male mutes. All vowed they would never repeat the offer. From now on this female was off limits.

A few days after the failed courtship dance, the young couple that had first accepted her showed up on the gravel bar with five signets on the female's back. They were so small and so vulnerable that, as the signets clambered down and started pecking at the gravel, Serene swam forward, her heart going out to the chicks. Recognizing her, and noting she was still alone, the male mute allowed her to come close and the proud parents accepted her soft honk of approval. Serene's own desires faded as she was allowed to stay with the new family. Watching over the new brood, seeing them grow, laughing at their antics, all helped her to forget her own troubles. She even forgot her nest.

Although the summer was hot and dry Serene had become acclimatised to the heat and, as in the previous year, spent most of her time with the young signets. One day rolled into the next and before long it was fall again. The salmon had started their run up the river. The days grew cooler and the rains started in earnest. After almost three years in the bay Serene had learned to recognize the signs. When she heard the first distant trumpet, she didn't paddle out into the bay in excitement as she had the year before. Instead she turned and swam back to the family and waited.

A large trumpeter flock appeared flying low over the tops of the trees. A small group broke formation, gliding along the shore line searching. Still Serene waited. It wasn't long before the trumpeters spotted her and came in to land a respectable distance from the small group. Only then did she dip her head toward the male mute and gave him a soft honk of farewell. Whether it was a thank you or an apology only another trumpeter would know, but the male mute accepted the honk and dipped his head in acknowledgement.

Duty to her summer friends and the call of the trumpet tore at Serene. She had developed feelings for the mute swans that were hard to explain. She had helped raise two clutches of signets all of whom had learned to understand her honks even though they couldn't reply in her language, and she in turn had come to recognize their certain actions and hisses. Now her own children proudly introduced this year's hatchlings who all looked at her as if she were an unknown species. She looked back to her adopted family and watched as the mutes gathered their young. Knowing they were getting ready for the flight to the lake, she felt an unexplainable urge to go with them.

Before the week was out, the fields surrounding the marshes were again covered with trumpeters. Serene, now very familiar with all the channels, found ways to get to nearly all

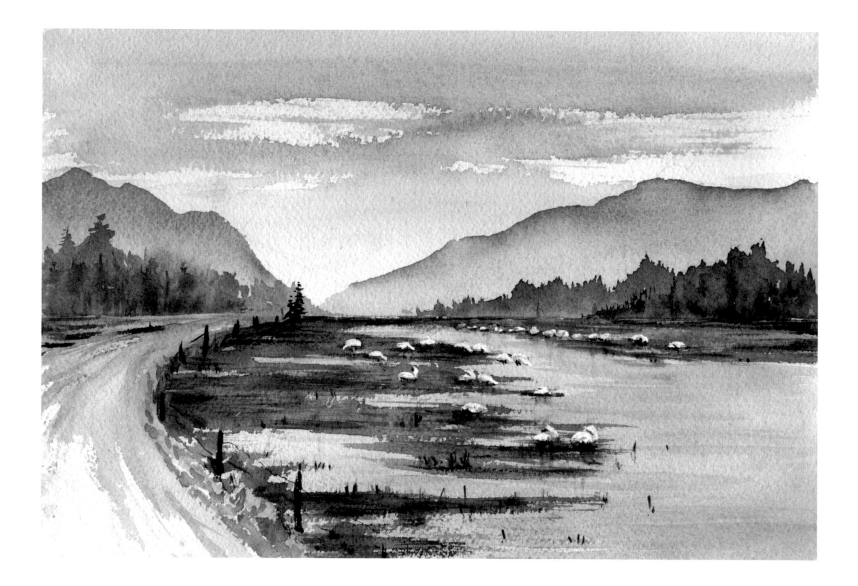

the different fields. Only those on the other side of the highway were out of reach. She enjoyed spending time with her brothers and sisters. It warmed her heart to have her own family close again and to have her honks understood. However hearing about the new nesting grounds, the changes in the weather, and all the other gossip quickly became irrelevant. Serene tried her best to show interest but it was all now such a distant memory that most of what they were telling her no longer had any meaning. Occasionally one would ask how she was doing but whenever she attempted to talk about her mute friends they were polite, but clearly puzzled at the affiliation. Not one of them had ever been totally alone. Before long Serene realized they would never understand and she stopped trying to explain.

There was, however, one swan who listened to her stories. He was a close friend of her brothers. During the last spring nesting season, he had been out feeding and returned to find his wife dead, their nest destroyed and the eggs gone. Where or by whom he had no idea. The nesting site was a new one and no-one else had seen or heard a thing. His wife had chosen the spot, close to a stand of trees, for protection from the winds. She hadn't considered that an animal might use those trees for camouflage. He had mourned his loss all summer, blaming himself for not staying close. Here on the marshes, as the ritual winter socializing gave way to courting, he mostly kept to himself.

Serene also found herself watching from the sidelines. As often happens when two creatures suffer a similar loss, they would acknowledged each other. Before long they were exchanging stories.

Understanding is the fundamental root of all relationships. As the winter days grew shorter, the two trumpeters found themselves seeking out each other's company.

December rolled into January and the weather turned harsh. Arctic winds cut through the valley from the Northeast bringing heavy snow from the mainland. Waking up to a particularly bitter morning, where icicles hung from the branches and sheets of ice covered the shallows, Serene suddenly remembered her nest. She indicated to the male trumpeter, who was resting nearby, to follow her.

Curious, he followed her through the marshes until they came to the pilings where he watched in astonishment as she swam to the large pile of snow covered logs and then ... vanished. He paddled closer and her head appeared from between two large stumps. Serene lowered her head and gave a quiet, almost shy, honk of invitation. Amused and surprised, the male trumpeter followed her into the cavern that had been created by storms.

Inside the ground was free of snow. The sandy soil was a little damp but compared to outside, it was warm and cosy. To his surprise more than half the space was taken up with the most perfect nest he had ever seen. He could see it had never been used. He looked at Serene, even with her broken wing she was still a beautiful bird. That she had built this nest knowing full well that her mate was dead, tore at something deep within his breast.

There was nothing but bad memories for him in the north. As he looked at the nest, then back to the brave majestic bird who had built it, he pictured her sitting here on her eggs while he stood guard. Emotions stirred from deep within his breast, he had found a new soul mate. He lay his head across her neck and Selene knew when the flock flew north this spring he would not be joining them. He was staying right here.

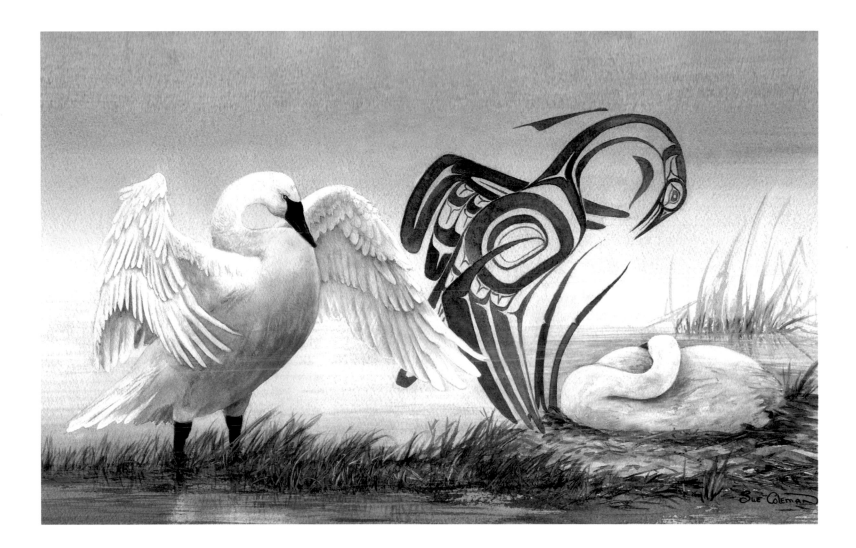

Other titles written by Sue Coleman

Art Books

An Artist Vision
Artist at Large in the Queen Charlotte Islands
Artist at large in Alaska

Children's Books

Biggle Foo meets Stinky
Biggle foo becomes a Legend

Novels

Return of the Raven

Visit
www.suecoleman.ca

Email: **Sue@suecoleman.ca**

Serene

48